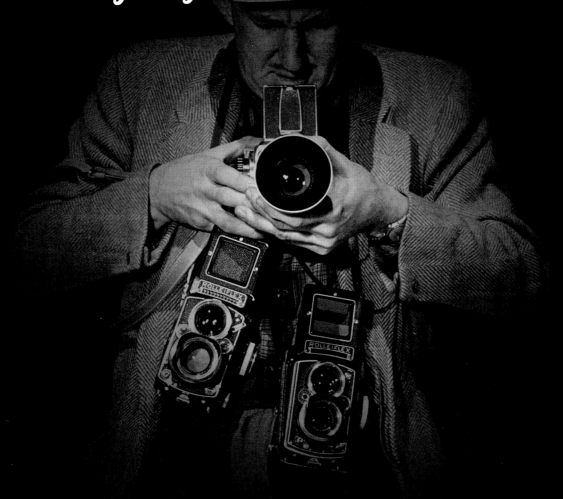

George Hunter's Canada

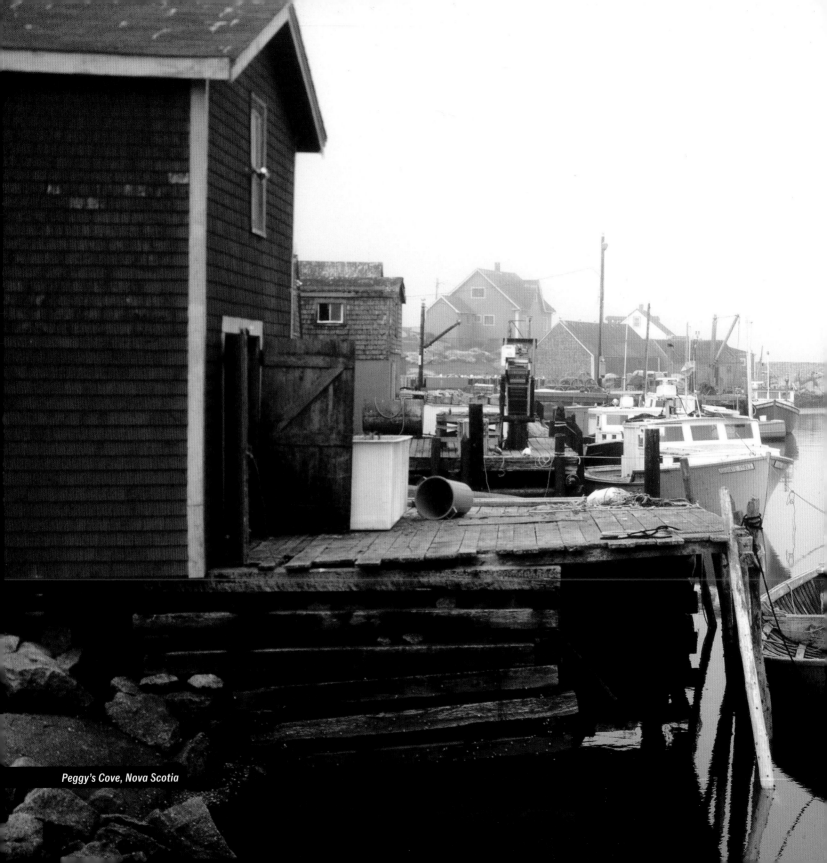

Peggy's Cove, Nova Scotia

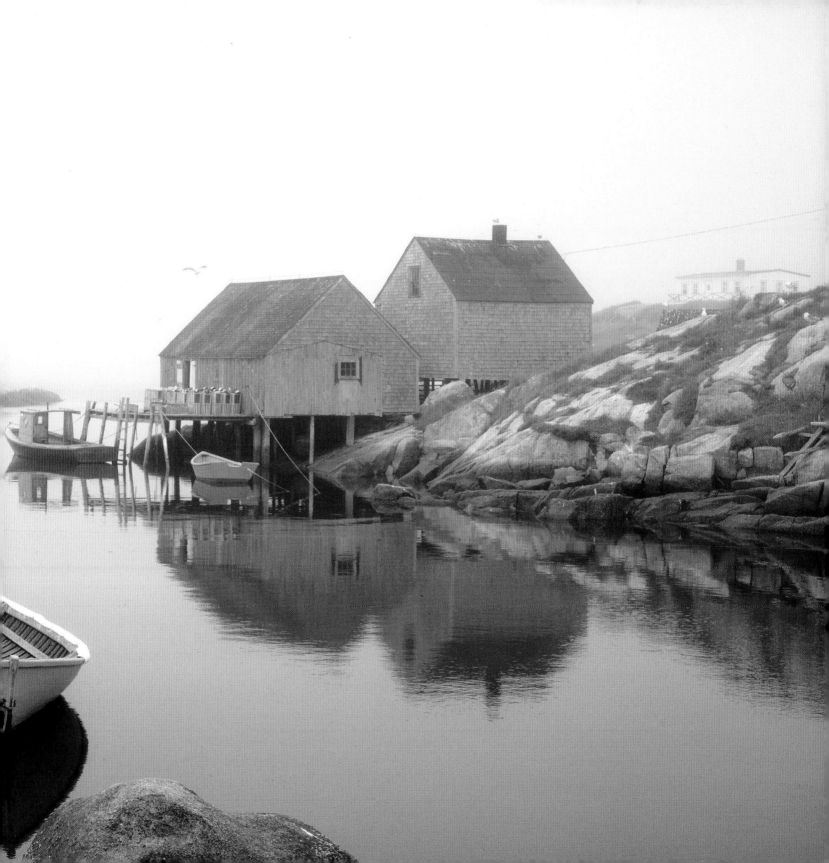

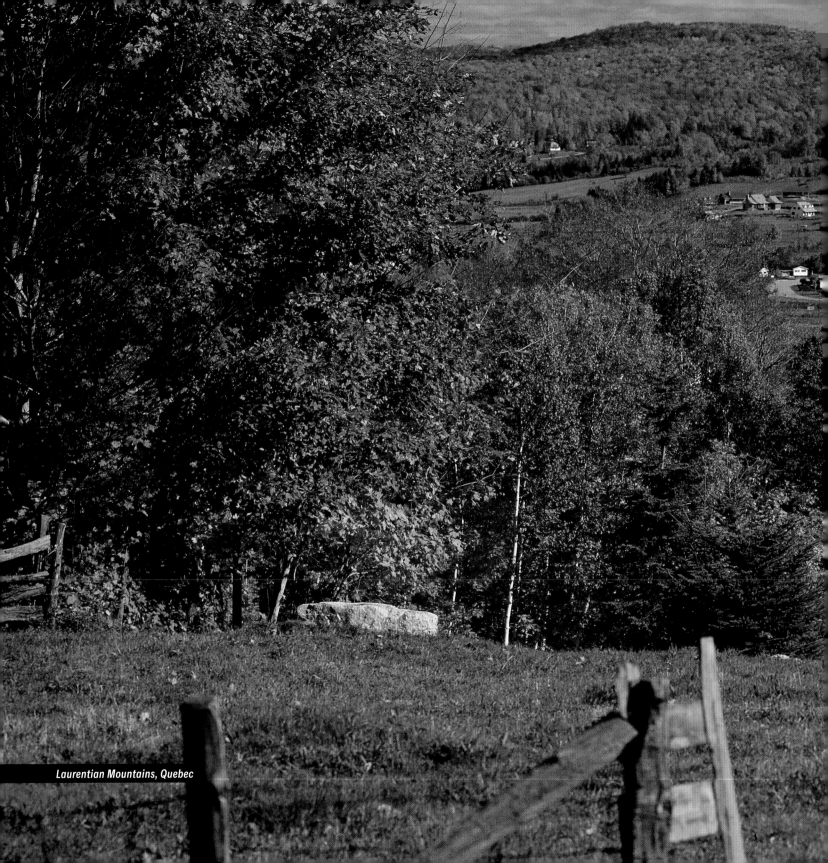

Laurentian Mountains, Quebec

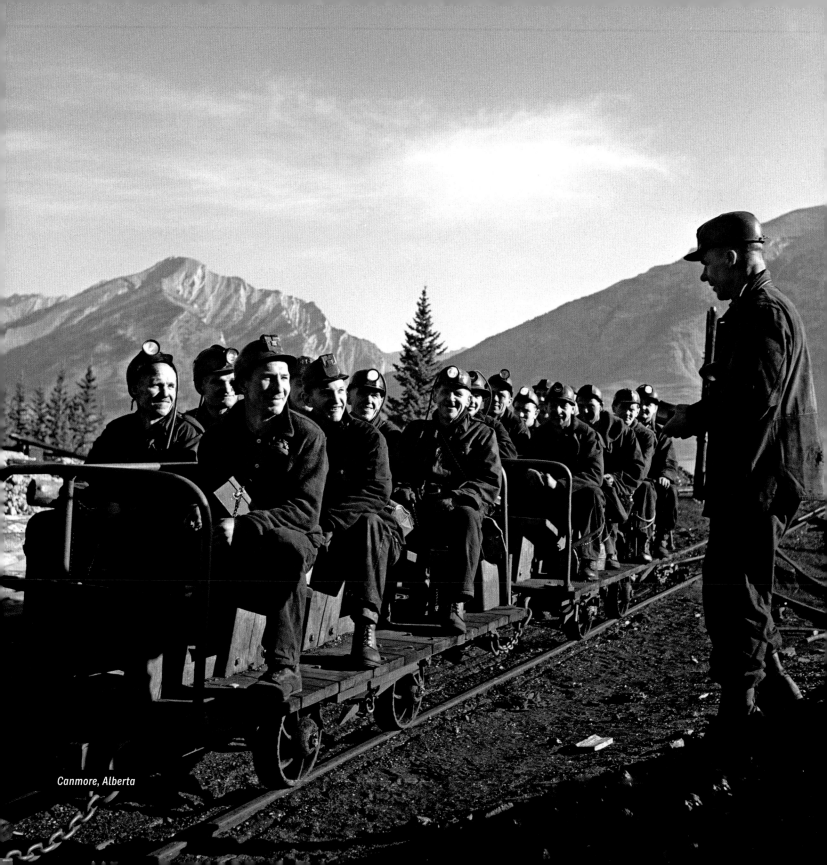

Canmore, Alberta

George Hunter's
CANADA

Iconic images from Canada's most prolific photographer

National Film Board of Canada Collection

FIREFLY BOOKS

A FIREFLY BOOK

Published under license by Firefly Books Ltd. 2017

Adapted from the interactive web series *Legacies 150: George Hunter*

First printing

Publisher Cataloging-in-Publication Data (U.S.)
Names: Hunter, George 1921–2013, photographer. | Cameron, Steve,
 editor.
Title: George Hunter's Canada : Iconic Images from Canada's Most
 Prolific Photographer / Edited by Steve Cameron, Photographs by
 George Hunter, Introduction by Nicholas Klassen.
Description: Richmond Hill, Ontario, Canada : Firefly Books, 2017.
 | Summary: "A selected catalogue of George Hunter's finest
 photographs from his 70-year career, as well as an intimate portrait
 of postwar Canada, its landscapes and its people" – Provided by
 publisher.
Identifiers: ISBN 978-0-22810-001-0 (hardcover)
Subjects: LCSH: Canada – Pictorial works. | Hunter, George, 1921–2013.
 | BISAC: HISTORY / Canada / General. | PHOTOGRAPHY / Individual
 Photographers / General.
Classification: LCC F1016.H868 |DDC 971.064– dc23

Library and Archives Canada Cataloguing in Publication
A CIP record for this title is available from Library and Archives Canada

Published in the United States by
Firefly Books (U.S.) Inc.
P.O. Box 1338, Ellicott Station
Buffalo, New York 14205

Published in Canada by
Firefly Books Ltd.
50 Staples Avenue, Unit 1
Richmond Hill, Ontario L4B 0A7

Cover and text design: Counterpunch Inc./Linda Gustafson

Printed in China

The NFB is Canada's public producer of award-winning creative documentaries, auteur animation, and groundbreaking interactive stories, installations and participatory experiences. NFB producers are deeply embedded in communities across the country, working with talented artists and creators in production studios from St. John's to Vancouver, on projects that stand out for their excellence in storytelling, their innovation, and their social resonance. NFB productions have won over 5,000 awards, including 15 Canadian Screen Awards, 17 Webbys, 12 Oscars and more than 90 Genies. To access many of these works, visit NFB.ca or download the NFB's apps for mobile devices and connected TV.

CHPF | FPHC

The Canadian Heritage Photography Foundation (CHPF) is a registered Canadian non-profit organization dedicated to digitizing, restoring, and preserving significant images from the lifetime works of Canadian photographers — past and present — and making them available for those interested in appreciating Canadian history. Founded by George Hunter in 2001, CHPF is home to a rare and ever-growing collection of more than 100,000 images that provide a window into Canada's fascinating past, its rich cultural present and its rapidly evolving future. www.thechpf.com

Additional Photo Credits
Library and Archives Canada:
9, 10 (second row, left), 21 BR, 26, 66–67, 78
National Film Board of Canada/Library and Archives Canada:
10 (first row, left; second row, middle), 24 TR, 26, 48, 50–51, 52 TL & BL,
53, 56 TL, 58 TL
National Film Board of Canada:
20 BR, 21 TL
Image of bank note on page 12–13 used with the permission of
the Bank of Canada

Canadä

We acknowledge the financial support of the Government of Canada.

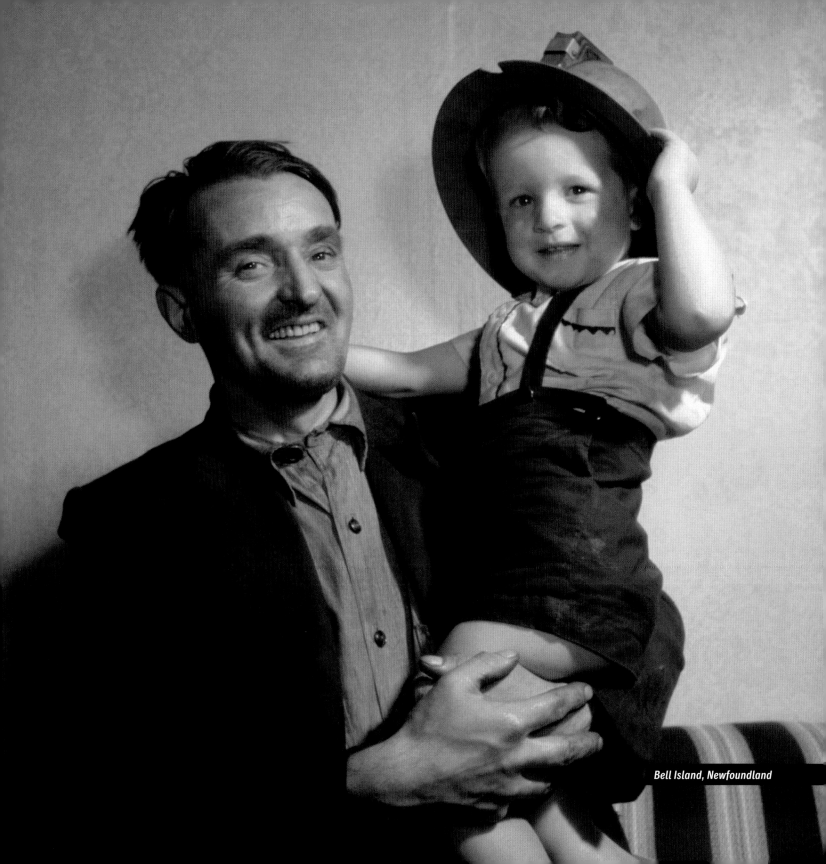

Bell Island, Newfoundland

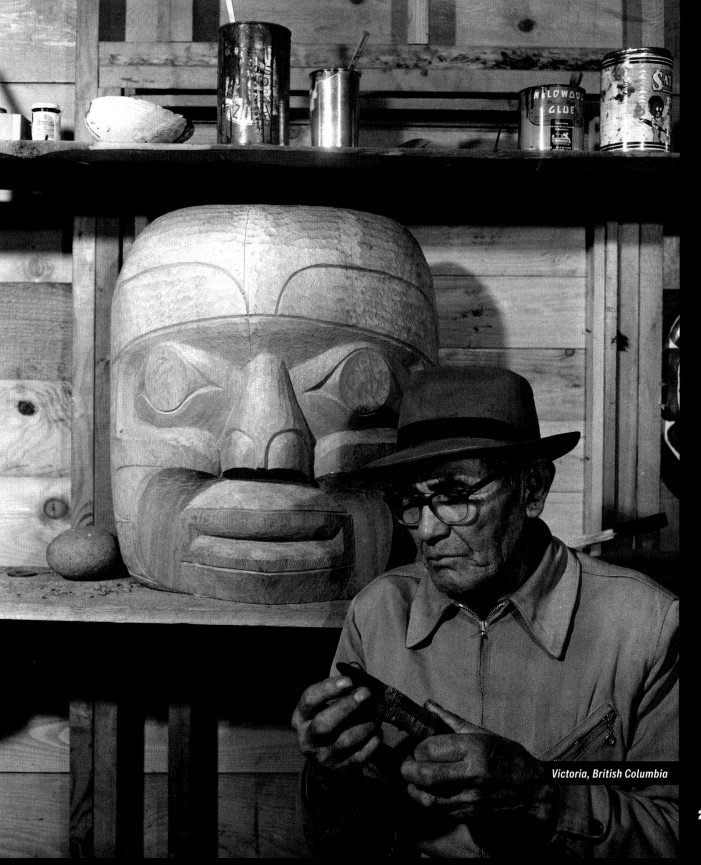

Victoria, British Columbia

25

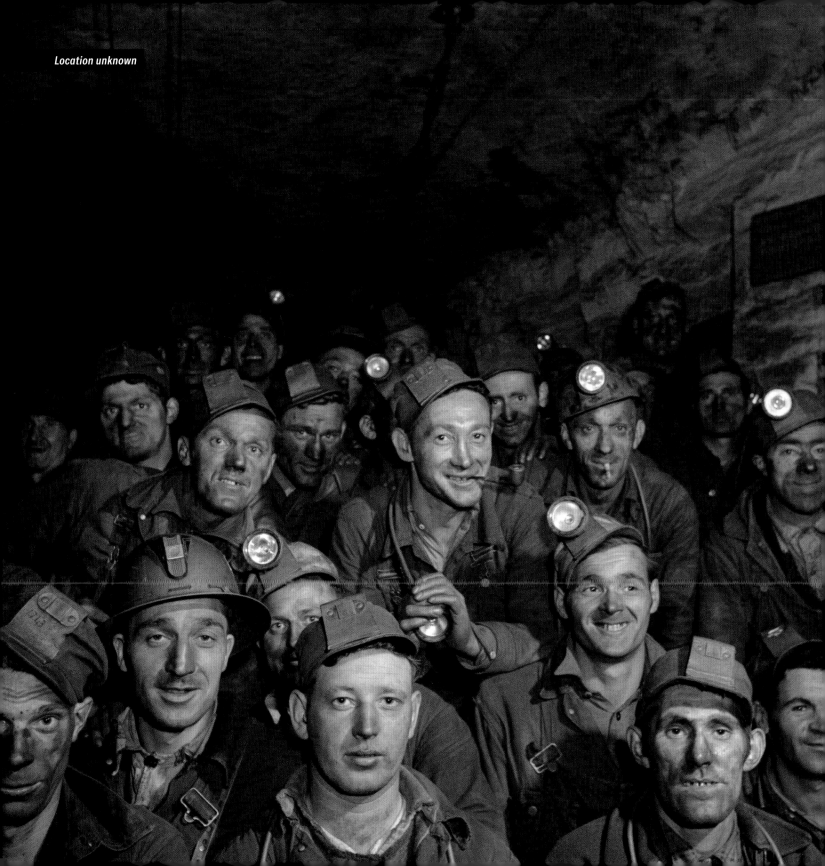

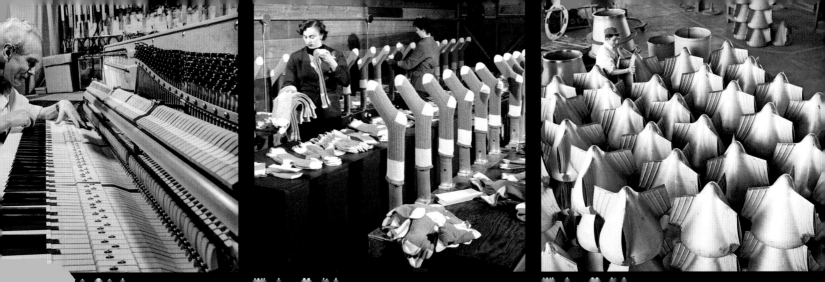

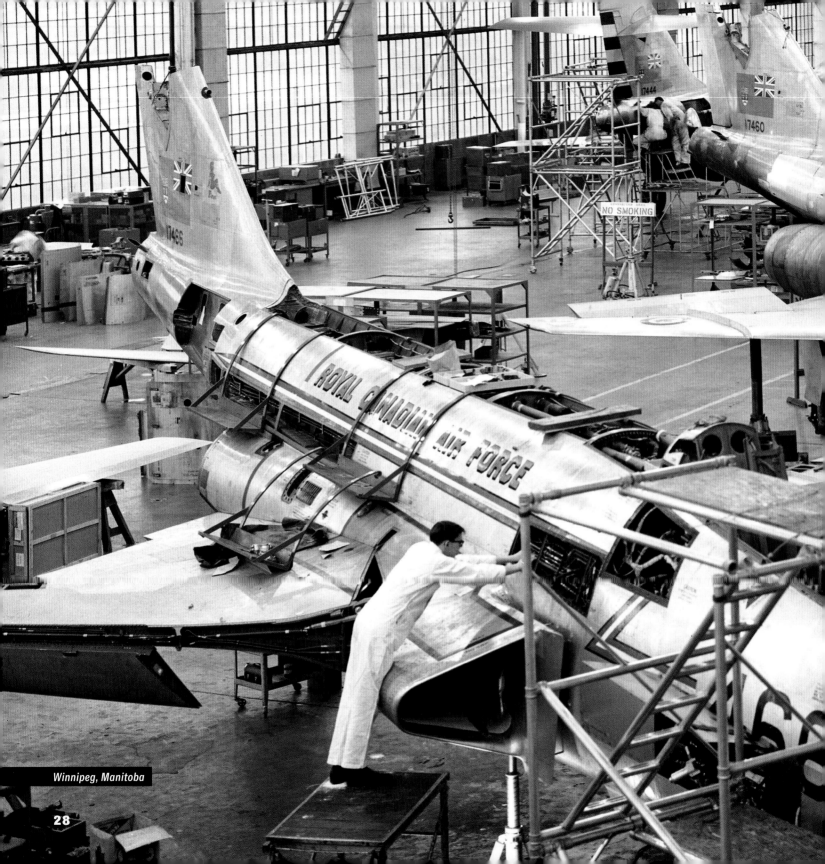

Winnipeg, Manitoba

28

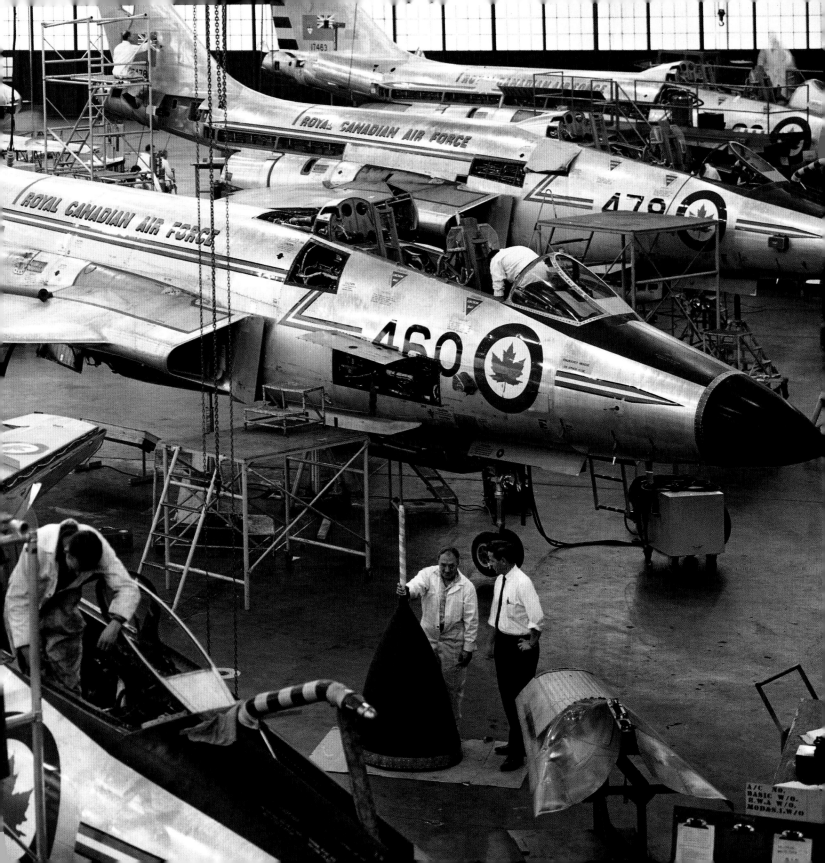

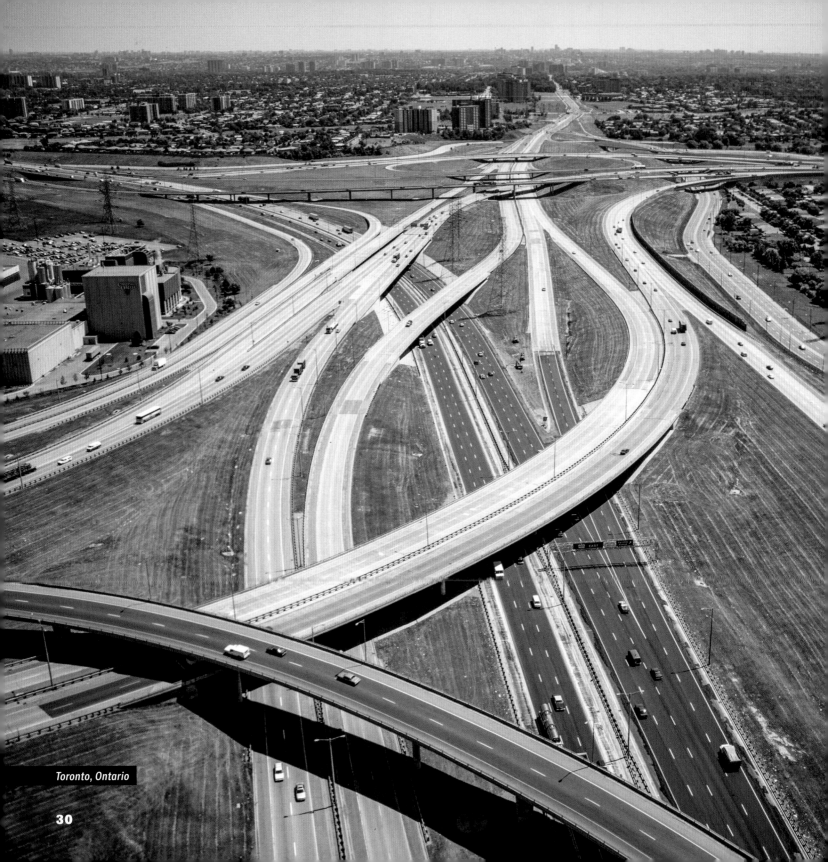

Toronto, Ontario

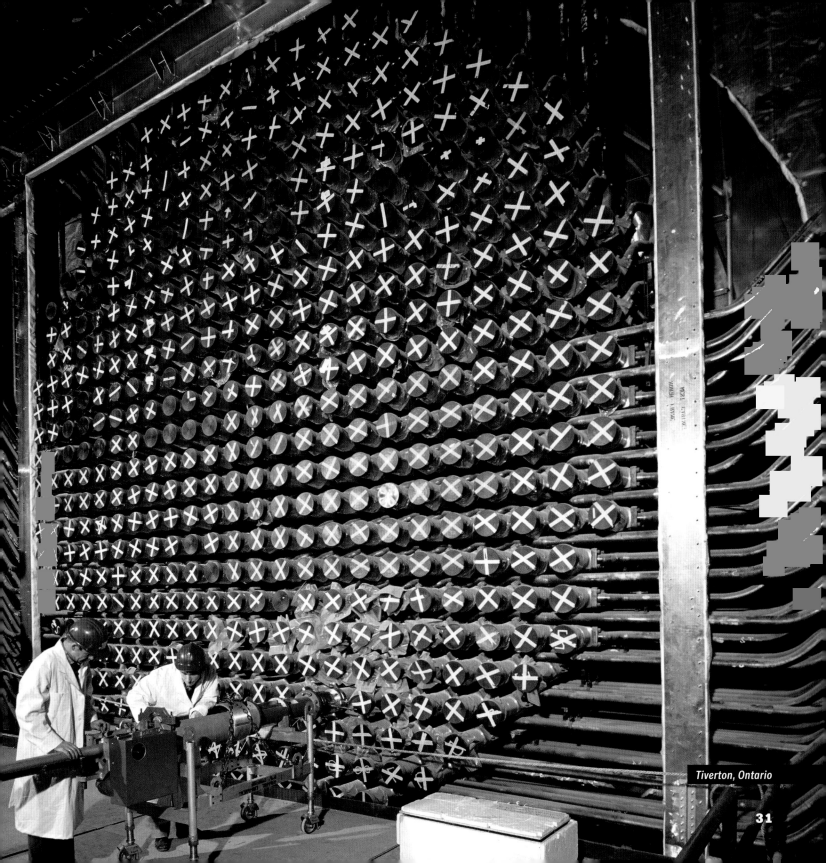

Tiverton, Ontario

31

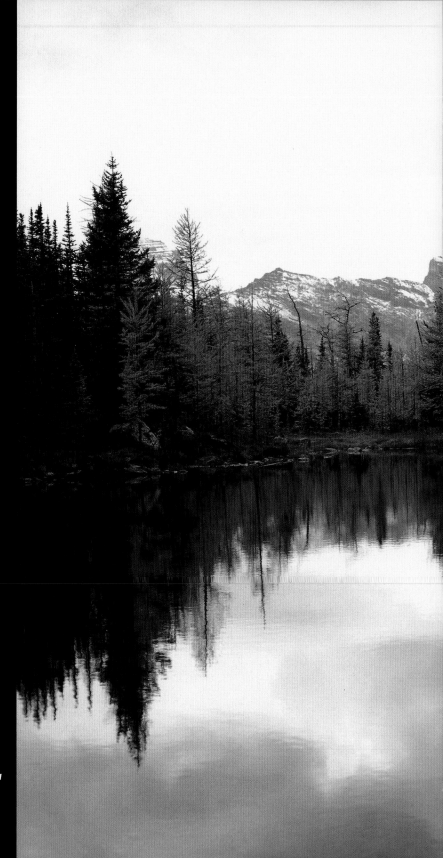

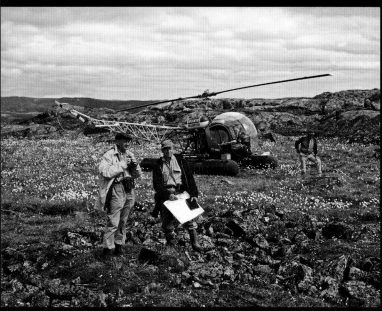

Tungsten, Northwest Territories

Yoho National Park, British Columbia

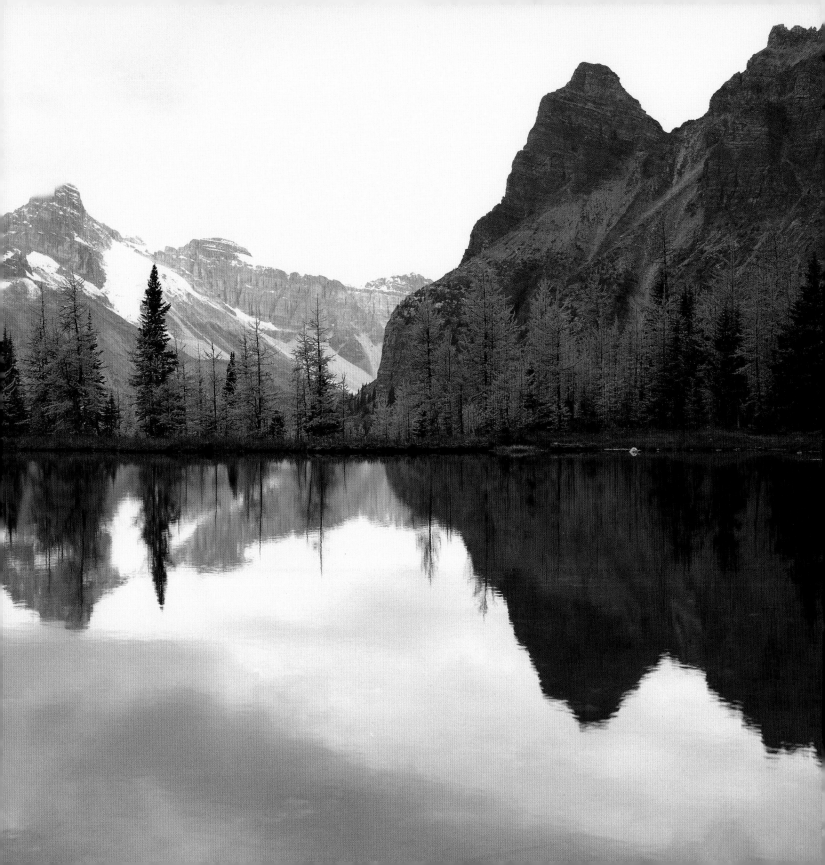

Technically, he was consistently ahead of the game, always using the latest in lighting and film development. Nothing was impossible for George.

When experts and all 46 staff photographers at *TIME* magazine insisted nighttime aerial photos "could not be done," the magazine's art director turned to George.

By stalling his plane just long enough for an exposure, he was able to capture illuminated cities for the first time. The results were so exceptional, *TIME* ran them as the largest photo spread in the magazine's history.

Those photos exemplify George's ultimate contribution: creating images that viewers had never seen before, taking them outside their normal sightlines and experience. In an era when air travel wasn't so accessible, before Google Maps and satellite imagery, his photos provided Canadians with a rare vantage point of their land. George Hunter shaped the way Canadians saw themselves and their country. They just didn't know it.

Part of George's anonymity is explained by Canadians' underappreciation of photography in general. It's true that he was one of the first photographers admitted to the Royal Canadian Academy of Arts in 1977, and today his work hangs in the country's most prestigious art galleries.

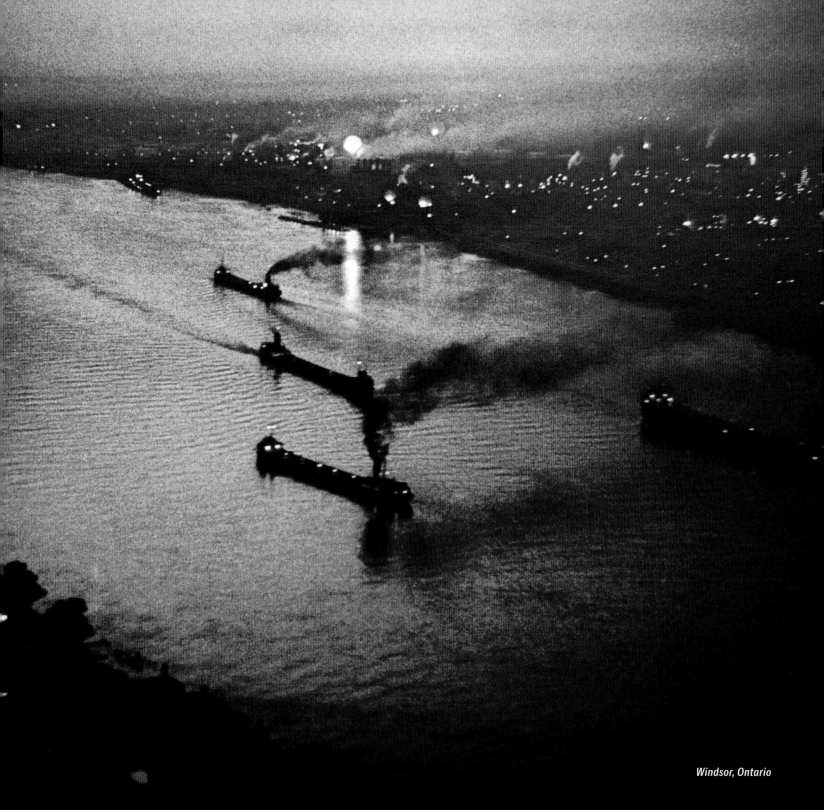

Windsor, Ontario

But during his career, photography was often seen as a "lesser-than" art form and Canadian photographers didn't have many exhibition opportunities outside small camera clubs and workshops. Today, his friend and former Art Gallery of Ontario photography curator Maia-Mari Sutnik struggles to reflect on George's individual legacy because of the lack of a larger national consciousness of Canadian photographic activity: "So far, we have skimped on this topic. Without publishing that captures George Hunter and other contributors to Canada's visual history, there will be no awareness — and we will be all the poorer for not documenting Canada's legacy in the field of photography."

George was acutely aware of this and strived to fix it. He told one chronicler, "Canadians don't appreciate photography as art. You rarely see it hung on walls and there are few collectors in Canada. And that's what I'm trying to do. I'm trying to elevate its stature in my own country."

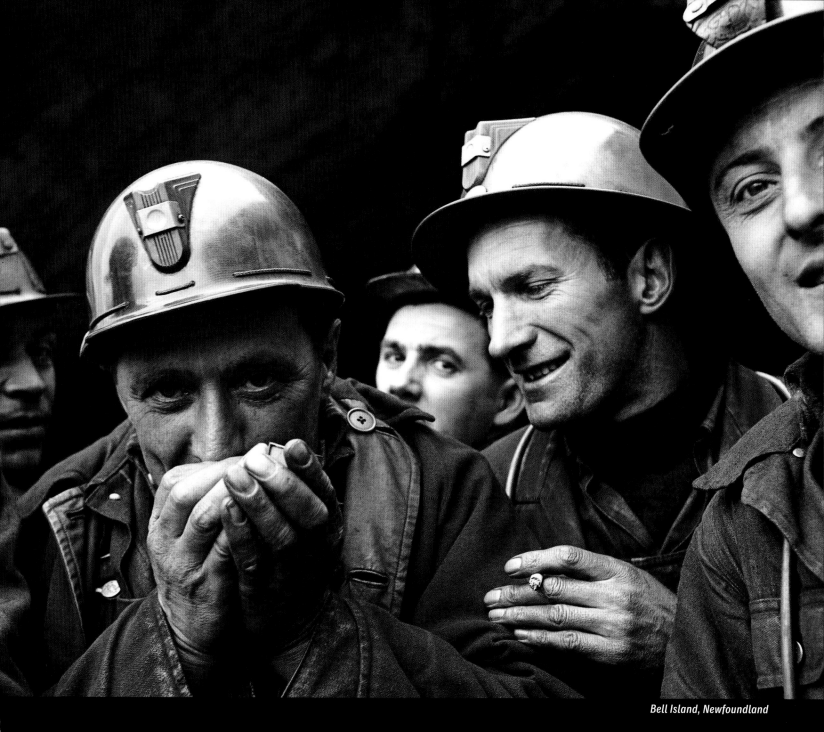

Bell Island, Newfoundland

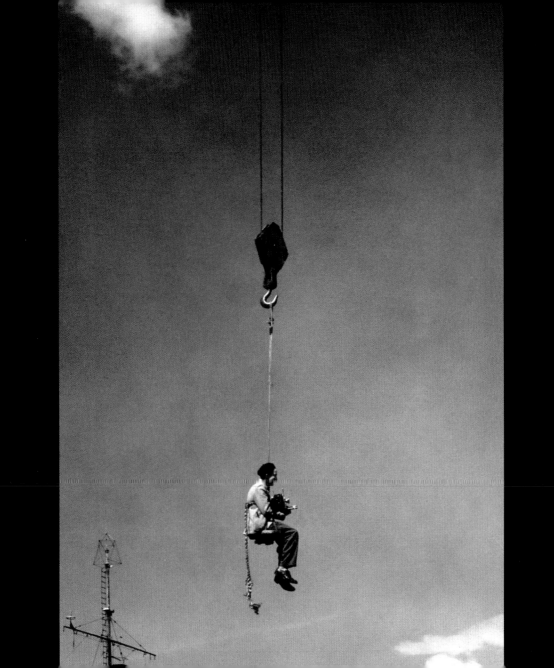

To achieve this, George spent his twilight years compiling sets of heritage prints, captioning each image and donating them to public galleries and museums across Canada. Before he died, he had several hundred prints in at least one public gallery or museum in every province and territory, except Nunavut. In his mission statement, he proclaimed, "I will not give up until every prominent public art institution across Canada has at least one of my heritage prints in their permanent collections." Appropriately, the day he went into the hospital for the last time, he was preparing for an exhibit at the RCMP Heritage Centre in Regina.

This resolve was borne not of vanity, but rather a deep and abiding love for his country. In fact, those who knew him best praise George as an unpretentious, humble guy.

So perhaps it's fitting that so few Canadians know who George is. He doesn't need your praise. He just wants you to see his photos and appreciate, as he did, that "Almost every part of the country has some magic to it when you look through a camera."

Nicholas Klassen, Interactive Producer, NFB.
June, 2017.

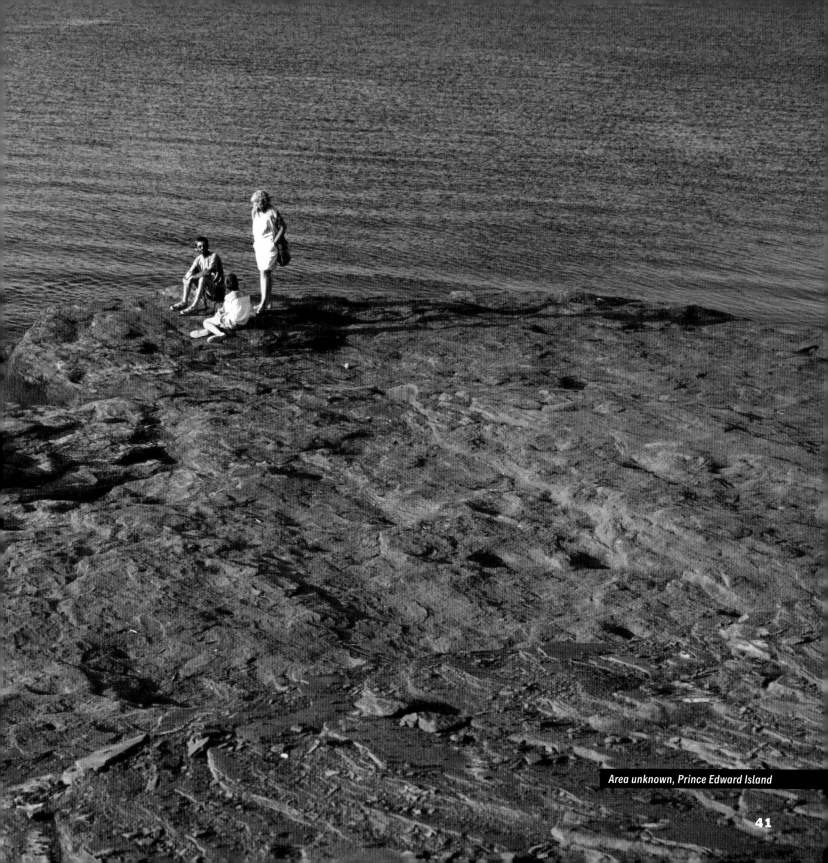

Area unknown, Prince Edward Island

41

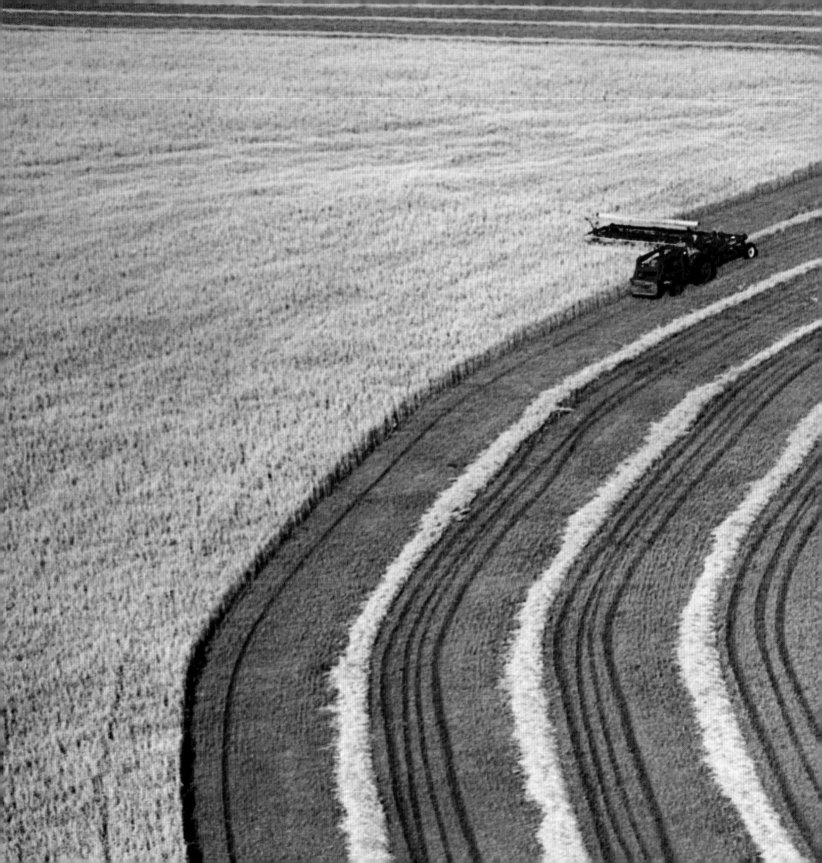

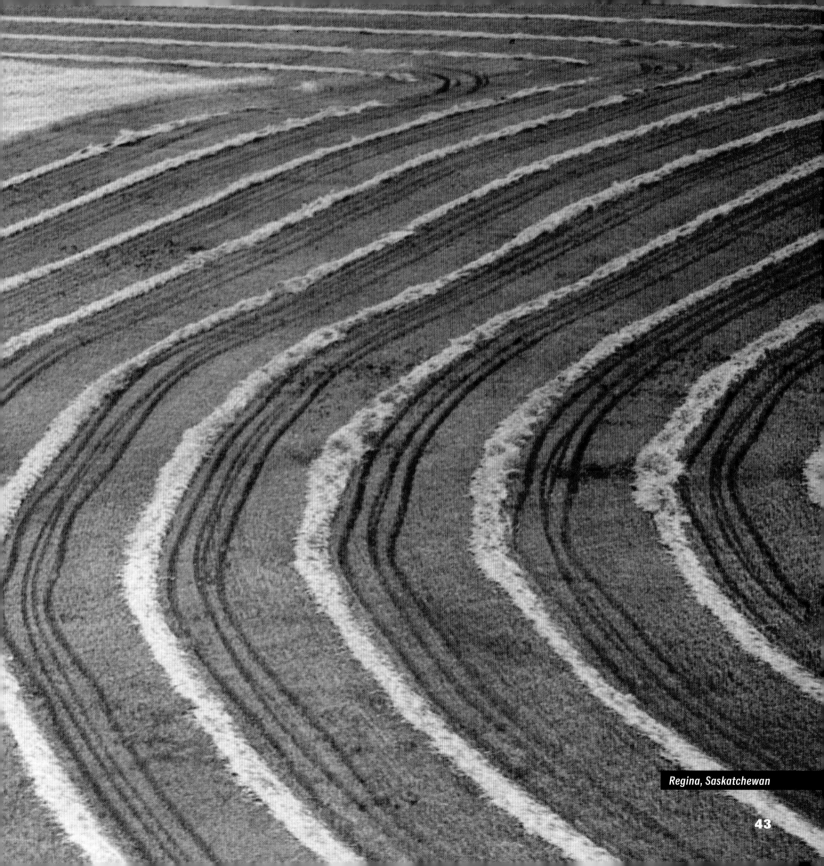

Regina, Saskatchewan

43

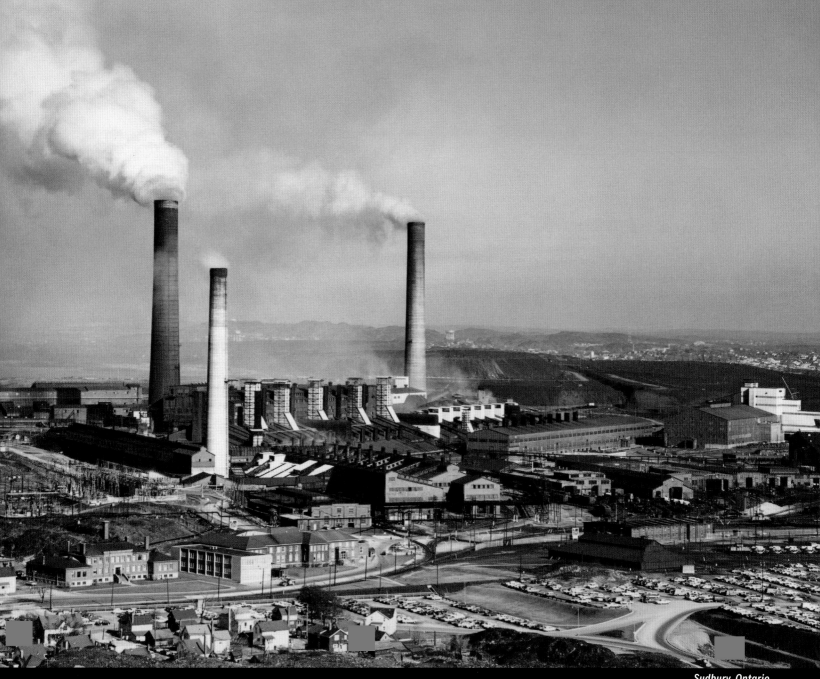

Sudbury, Ontario

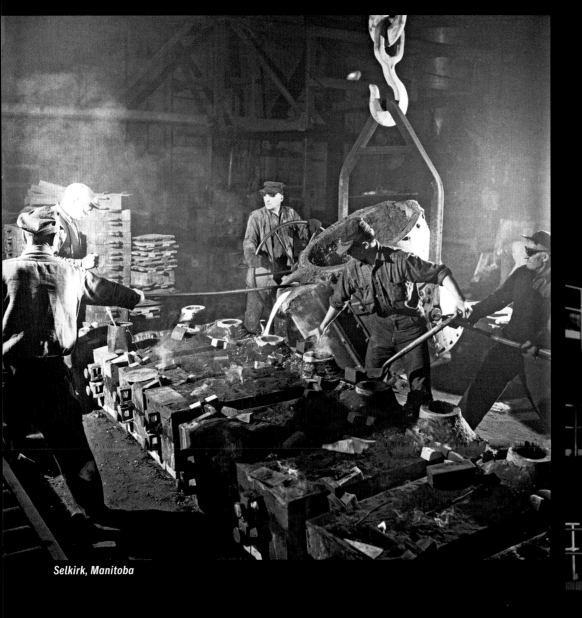

Selkirk, Manitoba

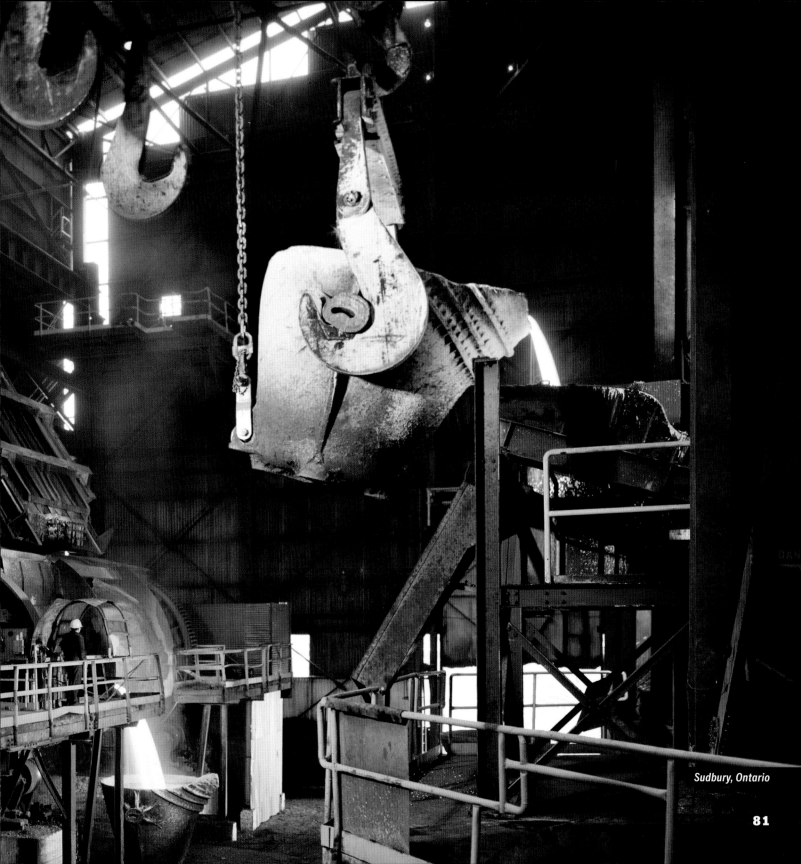

Sudbury, Ontario

81

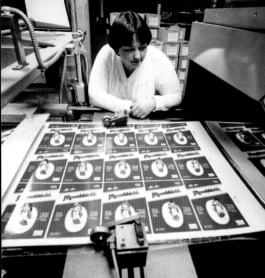

Concord, Ontario

Toronto, Ontario

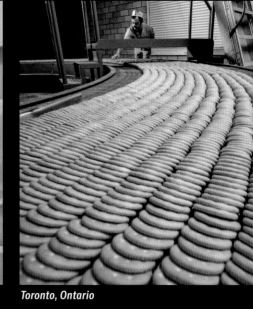

Toronto, Ontario

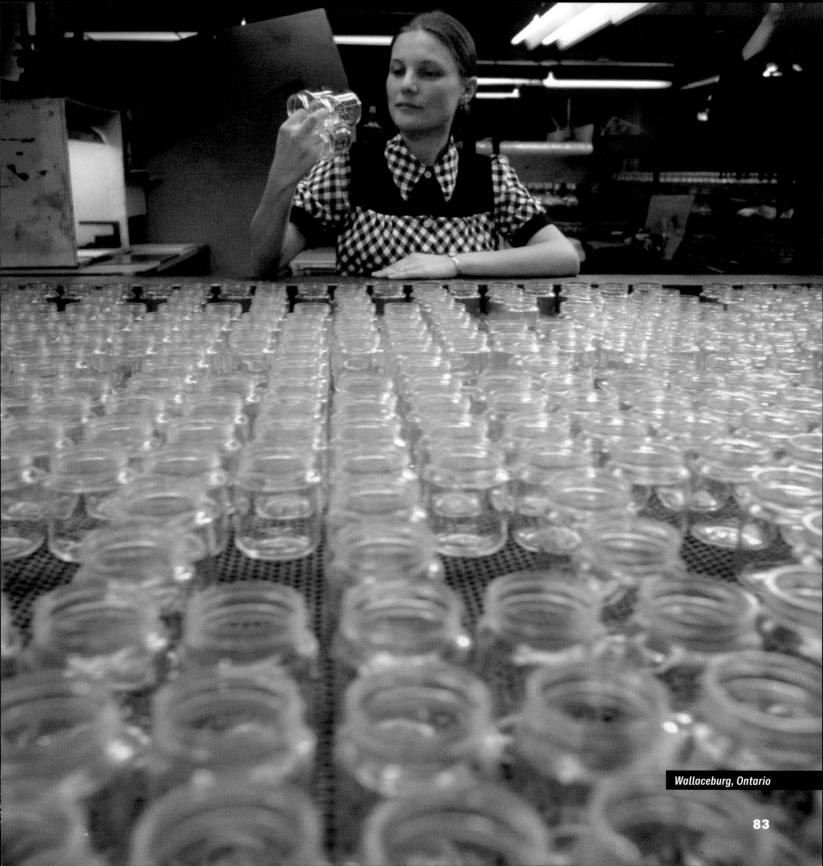

Wallaceburg, Ontario

83

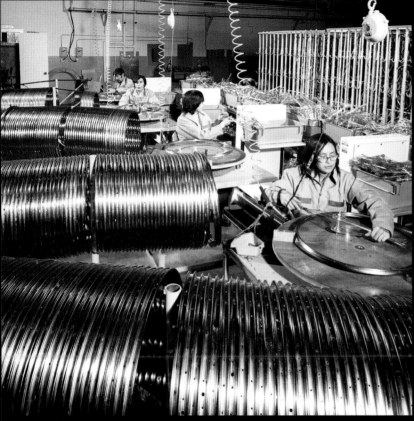

Rivers, Manitoba

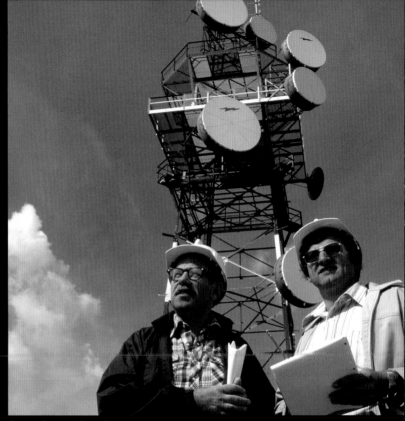

Area unknown, Ontario

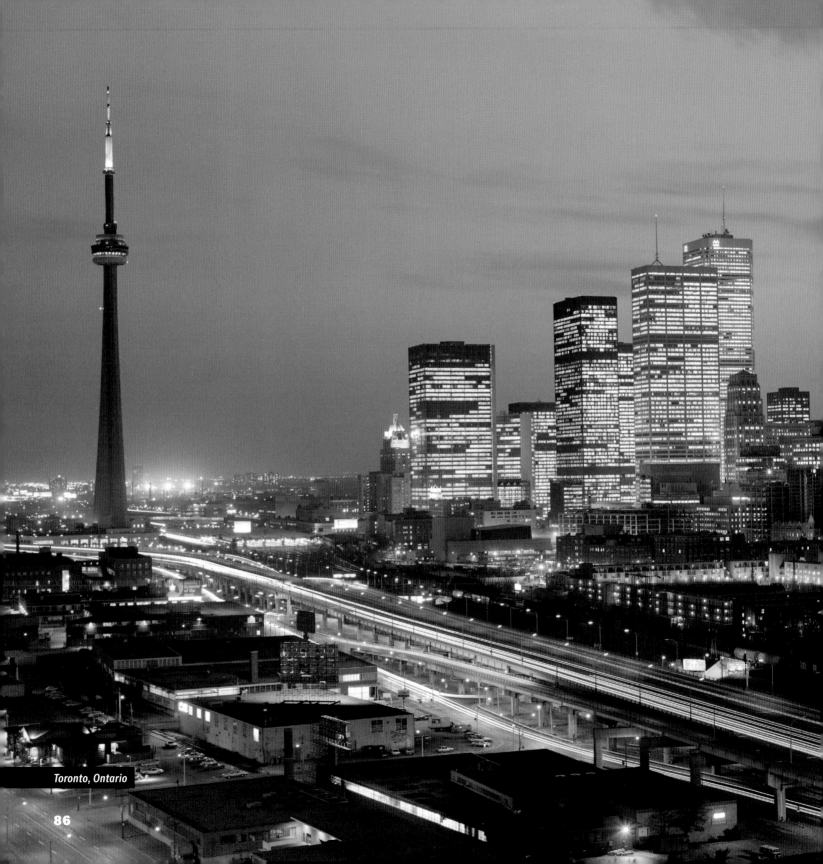

Toronto, Ontario

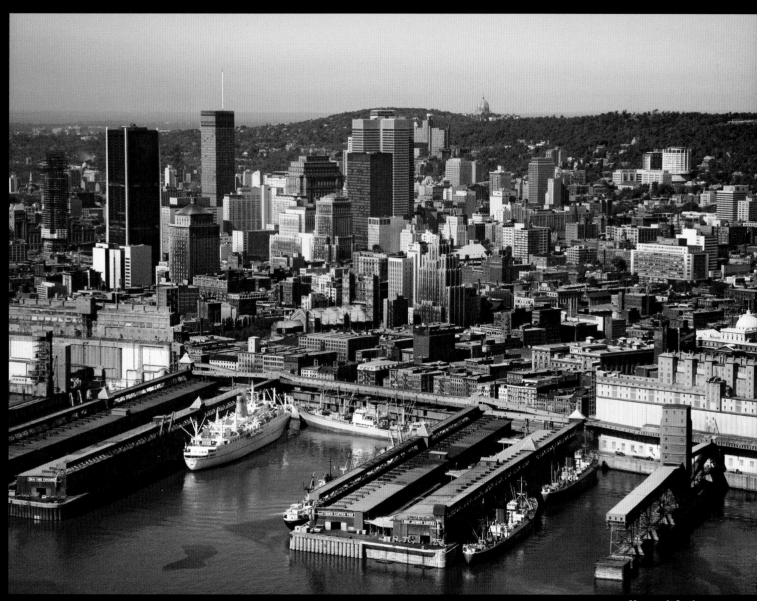

Montreal, Quebec

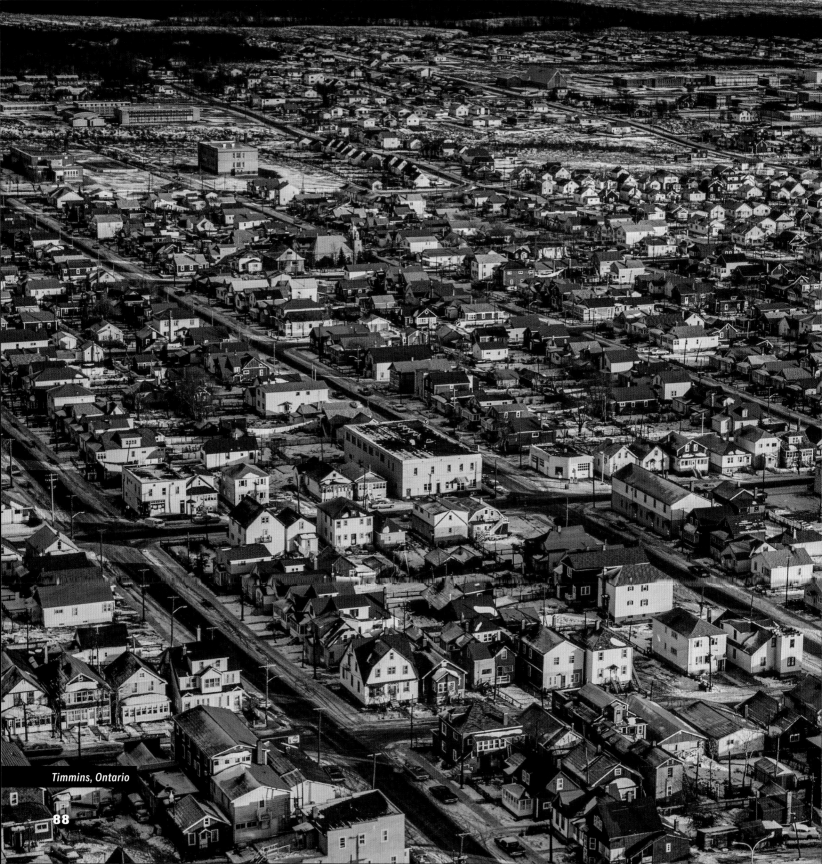

Timmins, Ontario

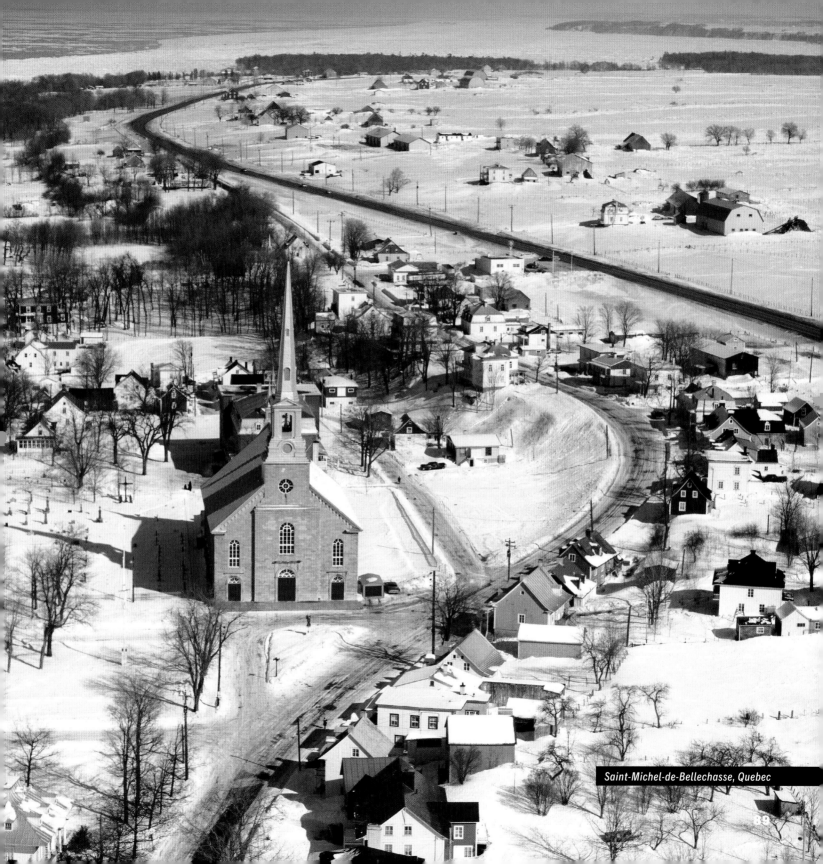

Saint-Michel-de-Bellechasse, Quebec

Colwood, British Columbia

Morse, Saskatchewan

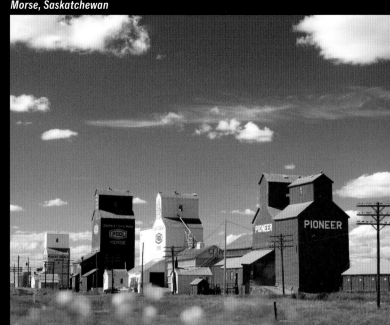

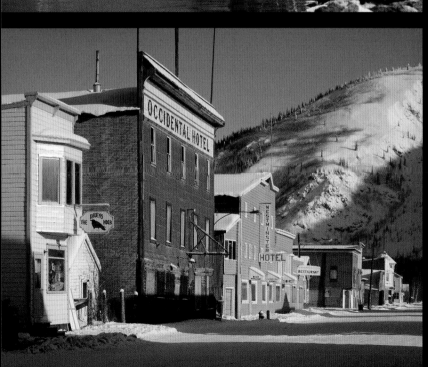

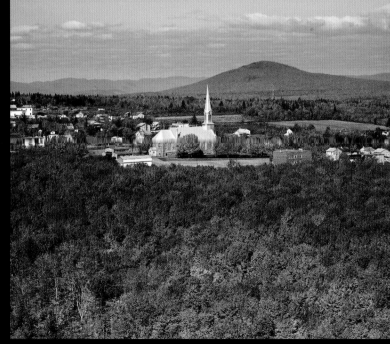

Dawson, Yukon

Laurentian Mountains, Quebec

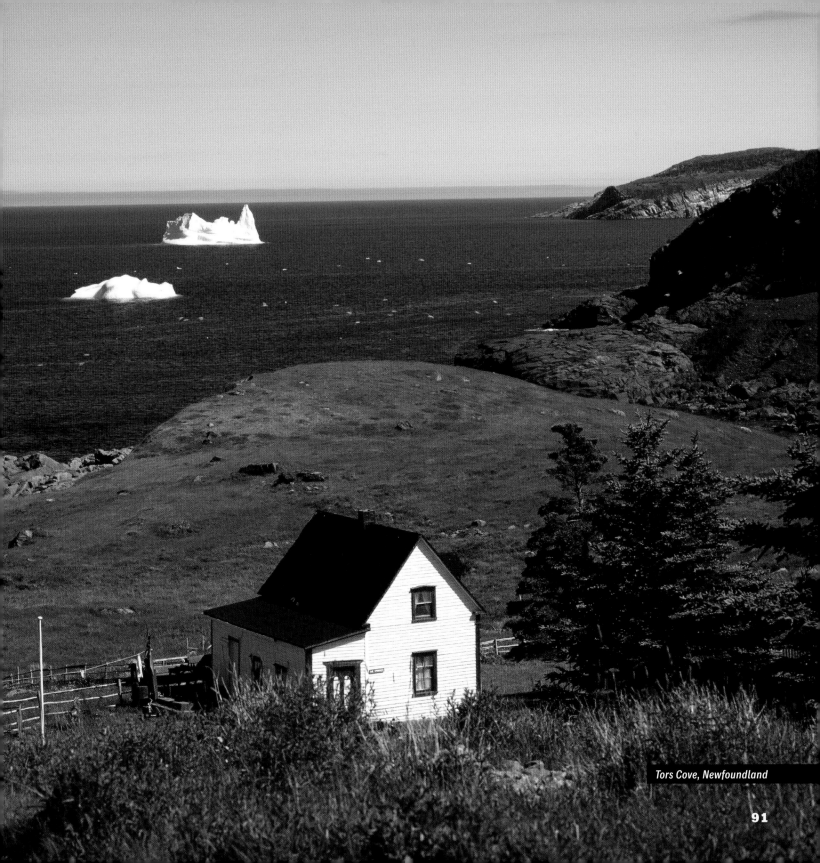

Tors Cove, Newfoundland

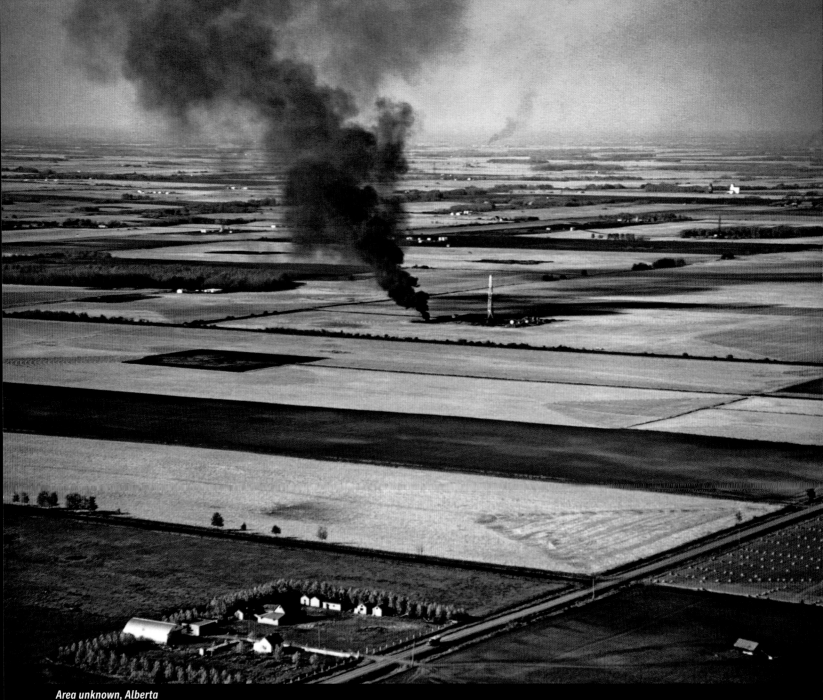

Area unknown, Alberta

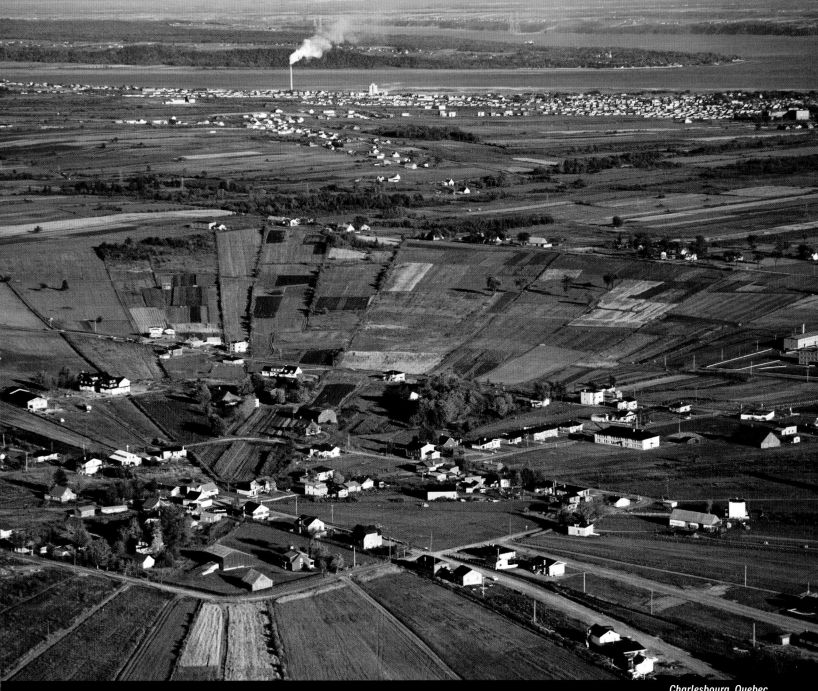

Charlesbourg, Quebec

Notes on Photographs

1. Photographer George Hunter focusing through the top viewfinder on his Rolleiflex camera.

9. Bill Jardine, a Bell Island mine foreman, with his son Tom in Newfoundland, 1949.

10. *First Row (L-R)*
 – Jimmy Gibbons, an Inuit deputy RCMP constable, at home with his family in Arviat, Nunavut, 1946.
 – A cat train (a train of large, connected sleds pulled by tractor) en-route to Thompson, Manitoba, 1957.
 – Family from Asbestos, Quebec, 1954.
 Second Row (L-R)
 – Aerial view of the Ontario Pavilion and the Canada Pavilion at Expo 67 in Montreal, Quebec, 1967.
 – VJ Day celebrations in Montreal, Quebec, 1945.
 – Selwyn Mountains, Yukon.
 Third Row (L-R)
 – Grand Beach, Manitoba,1942.
 – Harvested fields surrounding Gray, Saskatchewan, 1956.
 – Boys playing at the edge of a wide puddle in Winnipeg, Manitoba, 1940.
 Fourth Row (L-R)
 – Logging on the Saint-Anne River, Quebec, 1963.
 – Photographer George Hunter with a lion cub, 1959.
 – Rustico Harbour, Prince Edward Island, likely in the 1950s.

13. The *BCP45* Salmon Seiner fishing vessel off Ripple Point in Johnstone Strait, north of Campbell River, British Columbia, is seen hauling in a 10,000-pound sockeye salmon catch in 1958. Ollie Chickite is one of two men standing on the netting at the stern of the boat. He took ownership of the vessel in 1983.

The boat is now fully restored and on display at the Campbell River Maritime Heritage Centre.

14. Aerial view of Edmonton, Alberta, 1959.

16. A fisherman and his family atop a cod-drying flake in Chapel Arm, Newfoundland.

18. King George and Queen Elizabeth in Winnipeg, Manitoba, during their royal tour of Canada, 1939.

20. *L:* A self-portrait of photographer George Hunter during his time at the Bell Island mines in Newfoundland, 1949.
 TR: Aerial view of Parliament in Ottawa, Ontario, 1960.
 BR: A library worker at the National Film Board's motion picture library in Ottawa, Ontario, 1945.

21. *TL:* Second Engineer Jim McCullagh of the Canadian Government Steamship *C.P. Edwards*, 1947. The steamship's home port was in Parry Sound, Ontario.
 TR: Steel workers erecting a structure at an asbestos mine in Quebec's Eastern Townships, 1952.
 BL: Aerial view of Saskatoon and the South Saskatchewan River, 1953.
 BR: Dougal Doucette of Shediac, New Brunswick, holds up the first large lobster of the season, 1948.

24. *TR:* Mrs. J.M. McClelland, the first woman to arrive at the Matador Cooperative Farm in Kyle, Saskatchewan, 1946.
 BR: Radio operator Scotty Brodie at Con Mine in Yellowknife, Northwest Territories, 1952.

25. Artist Mungo Martin with his mask "Wild Woman" in his studio in Victoria, British Columbia. The mask was part of George Hunter's personal collection and now resides with the Canadian Heritage Photography Foundation.

26. Miners, 1949; unknown location.

27. *M:* Fairfield and Sons Ltd. sock factory in Winnipeg, Manitoba, 1952.
 R: Bristol Aero Industries in Winnipeg, Manitoba, 1956.

28. Bristol Aero Industries in Winnipeg, Manitoba, 1956.

30. Aerial view of the Highway 401 to Highway 427 interchange in Toronto, Ontario.

31. Reactor at Bruce Nuclear Generating Station in Tiverton, Ontario.

32. Dr. Jim Harrison of C.G. Survey checking claims with a prospector near Tungsten, Northwest Territories.

34. Photographer George Hunter flying a plane.

35. Aerial view of the Detroit River and Windsor, Ontario, 1954. This image is one of a handful of images George Hunter took for *TIME* magazine. The assignment, to photograph U.S. cities at night, was considered an impossible task. To do something never done before, George developed a unique technique of stalling his plane long enough to snap a "still" exposure. He was aided in his task by using the most sensitive film of the time, Aero Ektachrome (developed during World War II to take colour pictures of camouflaged installations), and a special Eastman Kodak 8 in. ƒ/1.5 lens (created during the war to capture photographs of explosions). The entire feature ran seven pages in the September 20, 1954, issue.

37. Iron ore miners in Bell Island, Newfoundland, 1954.

48. Inuit women and children walking in Pangnirtung, Nunavut, 1946.

50. Kangirjuaq works on a snow knife while his wife, Niviaqsarjuk, makes caribou footwear and their grandson, Ikkat, listens to music in Qamani'tuaq, Nunavut, 1946.

51. *TL:* A group of Inuit children watching supplies being unloaded from *R.M.S Nascopie* in Pangnirtung, Nunavut, 1946.
 TM: Tapatai, assistant to Rev. W.J.R. James of St. Aidan's Anglican Mission, is pictured in Qamani'tuaq, Nunavut, 1946.
 TR: Annie Akpalialuk and her oldest child, Davidee, in an *amautik* in Pangnirtung, Nunavut, 1946.
 BL: Angmarlik distributing biscuits to Inuit who unloaded Hudson's Bay Company supplies from *R.M.S Nascopie* in Pangnirtung, Nunavut, 1946. From left to right: Angmarlik, Ipeelie Kilabuk, Isiasie Angmarlik (boy with the hood), Kitturiaq (man with the hood), Pauloosie Angmarlik (man in the far back in front of the tools), Inoosiq Nashalik (younger man second from right), Sakey Evic (boy not wearing his hood) and Atagoyuk (man on the far right).
 BR: Aulaqiaq Duval threading a needle for sewing in Pangnirtung, Nunavut, 1946.
52. *TL:* Aasivak Evic hanging sealskin boots, *kamiks*, to dry in Pangnirtung, Nunavut, 1946.
 TL: An Inuit man with white fox furs in Taloyoak, Nunavut, 1962.
 BR: Soudlo uses a sewing machine to make clothes for her baby, Quaga, in Pangnirtung, Nunavut, 1946.
 BR: Louchex couple in Rocher River, Northwest Territories.
56. *T:* Alberta cowboy Steve Carson Lester, 1945.
58. *TL:* Don Messer's Islanders broadcasting from station CFCY in Charlottetown, Prince Edward Island, 1948.
 TR: Grace Jackson and Tim Brell taking advantage of the five-pin bowling alley at Con Mine's Jewitt Hall in Yellowknife, Northwest Territories, 1952.
59. Pearl Harbour Bar in Dawson, Yukon, 1950.

60. The packed lunch counter of the Kennedy Street Salisbury House in Winnipeg, Manitoba, late-1940s.
61. *TL:* A meat-packing plant in the St. Clair Avenue and Weston Road area of Toronto, Ontario.
 TR: Workers at the Campbell's Soup factory in Portage la Prairie, Manitoba, 1962.
 BL: Workers sorting potatoes for F.W. Pirie Company Limited in Grand Falls, New Brunswick.
 BR: A family makes bread in an outdoor wood stove in Cap-Chat, Quebec, 1954.
62. Workers at E.B. Eddy paper company in Hull, Quebec, 1952.
63. Trans-Canada Air Lines engine shop at Winnipeg Airport, Manitoba, 1954.
64. A worker operating rollers at the Great Lakes Paper Company in Thunder Bay, Ontario.
65. *L:* Workers assembling Sekine bicycles in Rivers, Manitoba.
66–67. Workers for the Labrador Mining and Exploration Company, 1949. From left to right: summer student Benson Blackie, driller Raymond Marquis, engineer Don Finlayson and driller Ed Bulman.
72. A barge pulling logs in Kootenay Lake, British Columbia, 1973.
73. A man standing near the edge of a Cassiar Asbestos Corporation mine in Cassiar, British Columbia, 1958.
75. Finished zinc ingots being checked for inventory in British Columbia.
76. Algoma Steel Corporation in Sault Ste. Marie, Ontario.
77. Aerial view of Flin Flon, Manitoba, 1952.
78. Welder Emile Francoeur of Sorel-Tracy, Quebec, welding in the Labrador Mining and

Exploration Company's shops at Burnt Creek, Newfoundland and Labrador, 1949.
79. INCO Copper Cliff smelter in Sudbury, Ontario, 1966.
81. Falconbridge Nickel Mines smelter in Sudbury, Ontario.
82. *L:* An operator checking packaging at a Parker Games plant in Concord, Ontario.
 M: Litton Industries aerospace gyro assembly in Toronto, Ontario.
83. A worker inspecting baby food jars in Wallaceburg, Ontario.
84. *L:* Workers at the Sekine bicycle factory in Rivers, Manitoba.
85. Sam the Record Man on Yonge Street in Toronto, Ontario.
87. Aerial view of Montreal and Mount Royal, 1968.
88. Aerial view of Timmins, Ontario, 1962.
90. *TL:* Fisgard Lighthouse, the oldest lighthouse in Western Canada, in the Esquimalt Harbour, Colwood, British Columbia.
96. Fireworks at Parliament Hill in Ottawa, Ontario, 1998.

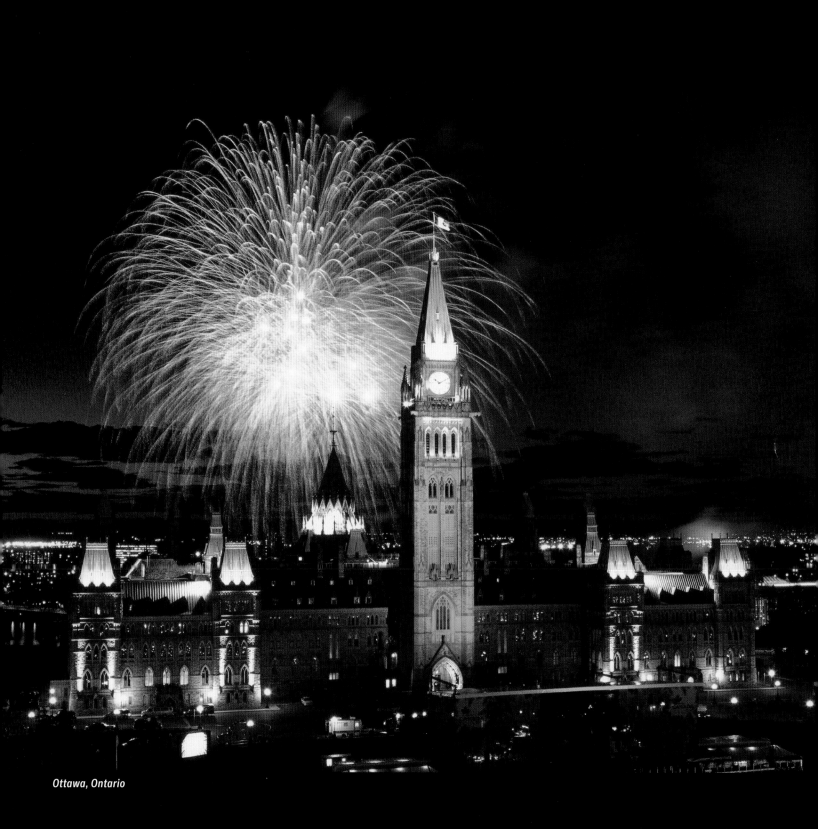
Ottawa, Ontario